Creative Cats
COLORING BOOK

MARJORIE SARNAT

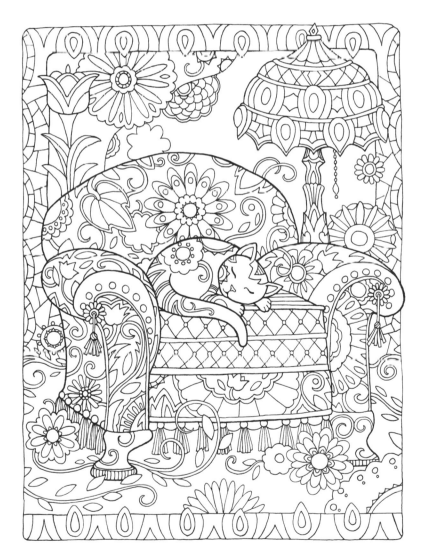

DOVER PUBLICATIONS, INC.
MINEOLA, NEW YORK

Featuring more than thirty fancy felines adorned with everything from paisley patterns and flowers, to music notes and steampunk accessories, this collection will satisfy the colorist and cat lover alike. The latest addition to Dover's *Creative Haven* series for the experienced colorist, the detailed designs provide endless opportunity for experimentation with color and technique. Plus, the imaginative background patterns, scenery, and borders give each plate a polished appearance. Once you are satisfied with your work, the perforated, unbacked pages allow for easy display.

Bibliographical Note

Creative Cats Coloring Book is a new work, first published by
Dover Publications, Inc., in 2015.

International Standard Book Number

ISBN-13: 978-0-486-78964-4
ISBN-10: 0-486-78964-0

Manufactured in the United States by LSC Communications
78964020 2019
www.doverpublications.com

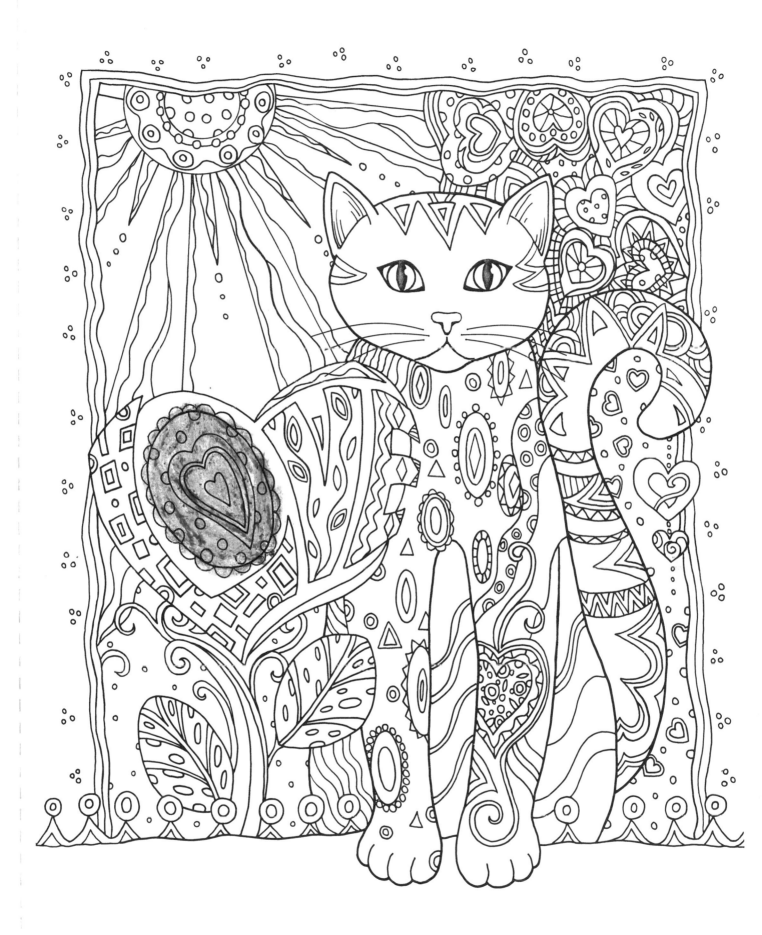

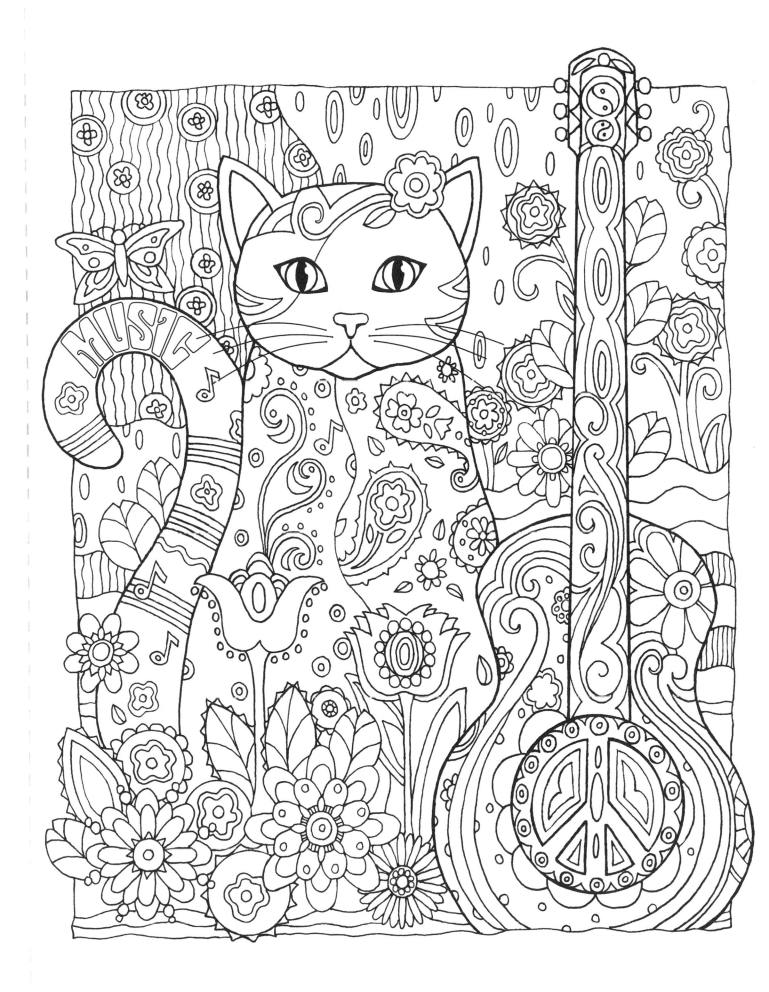

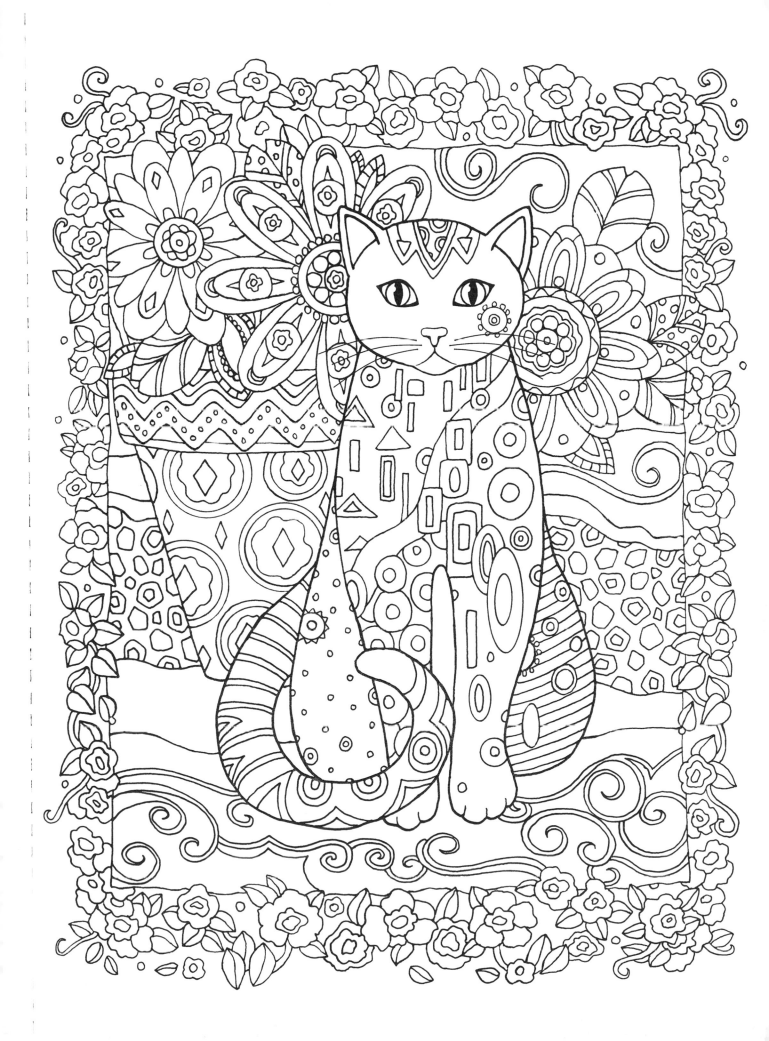

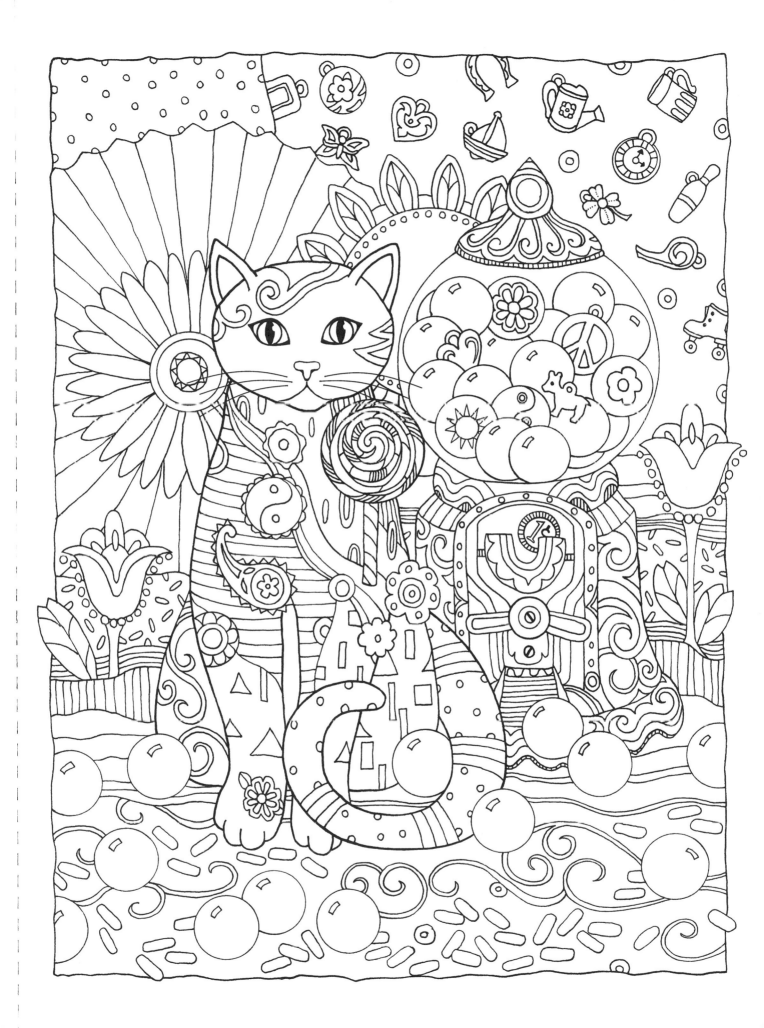

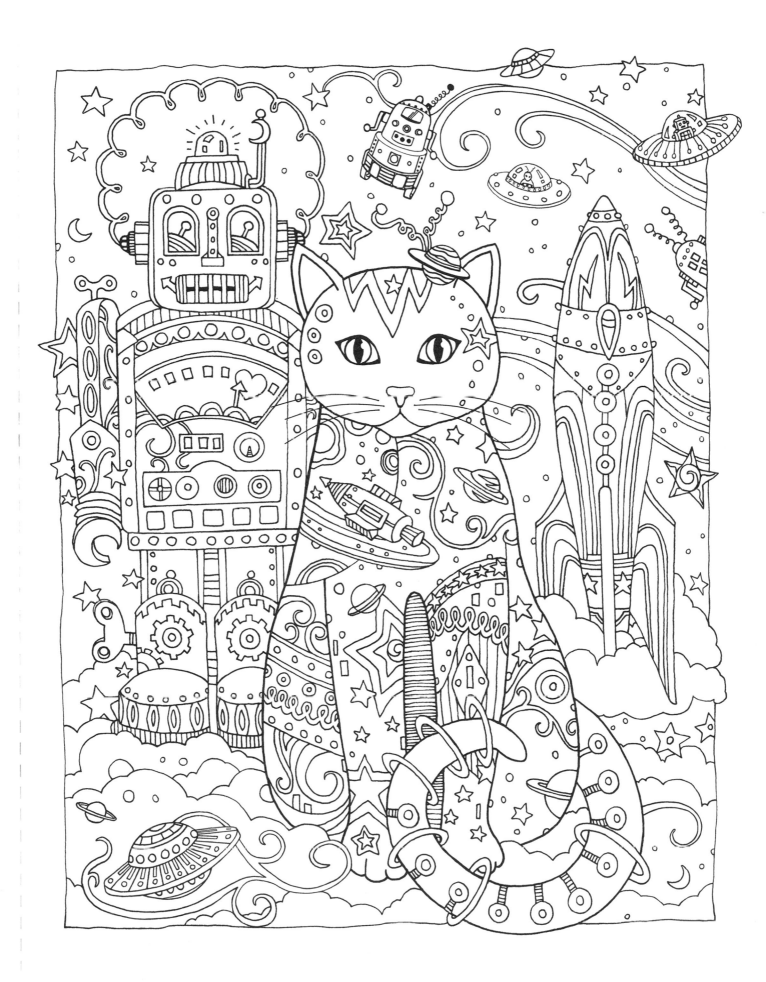

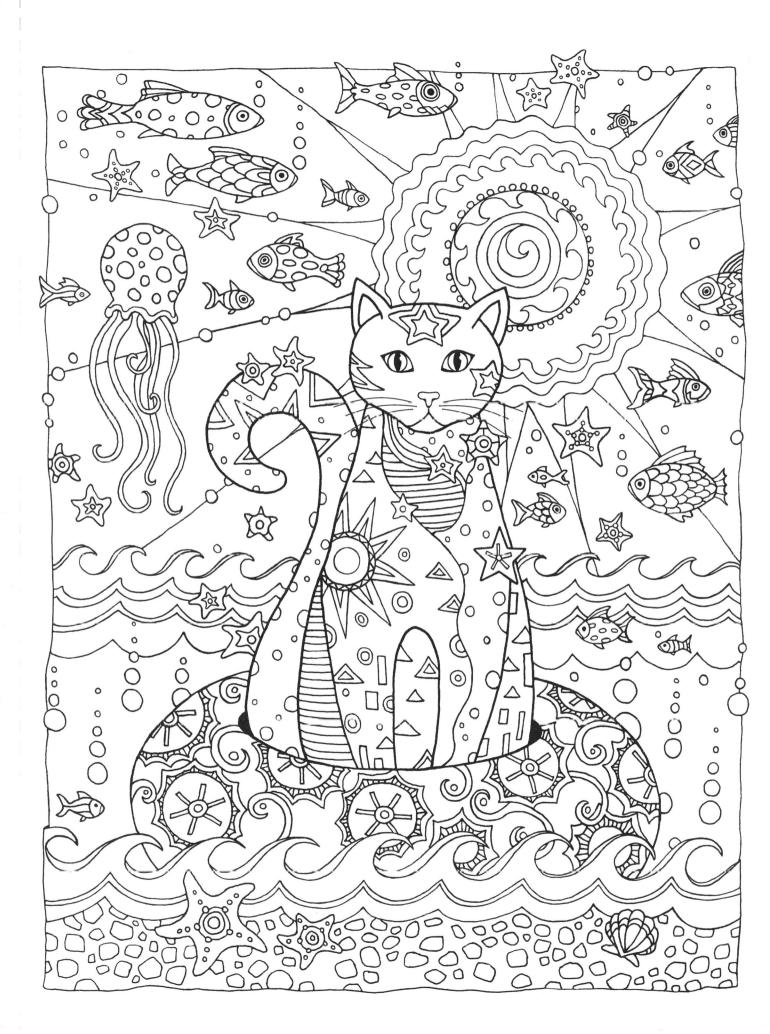

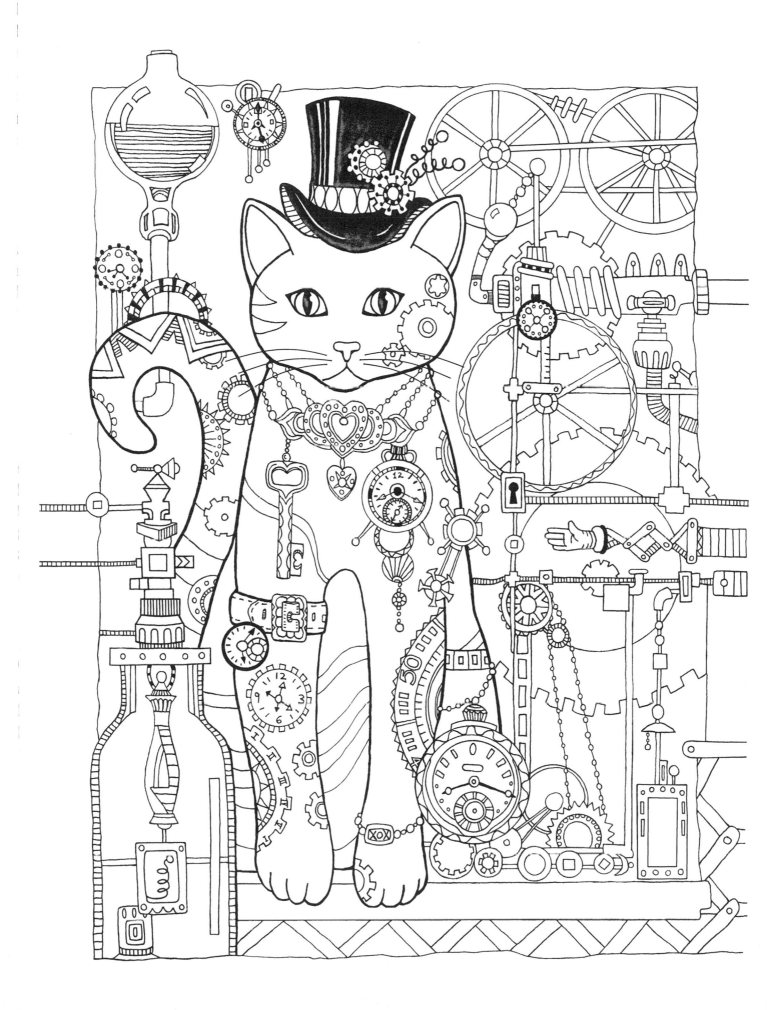

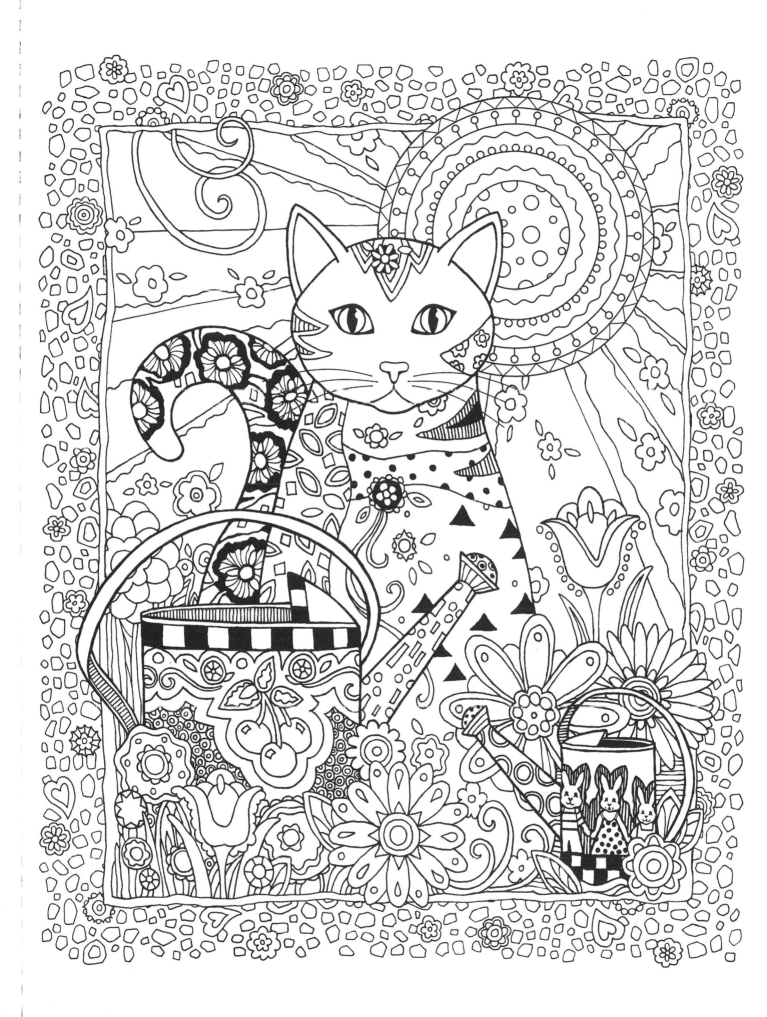

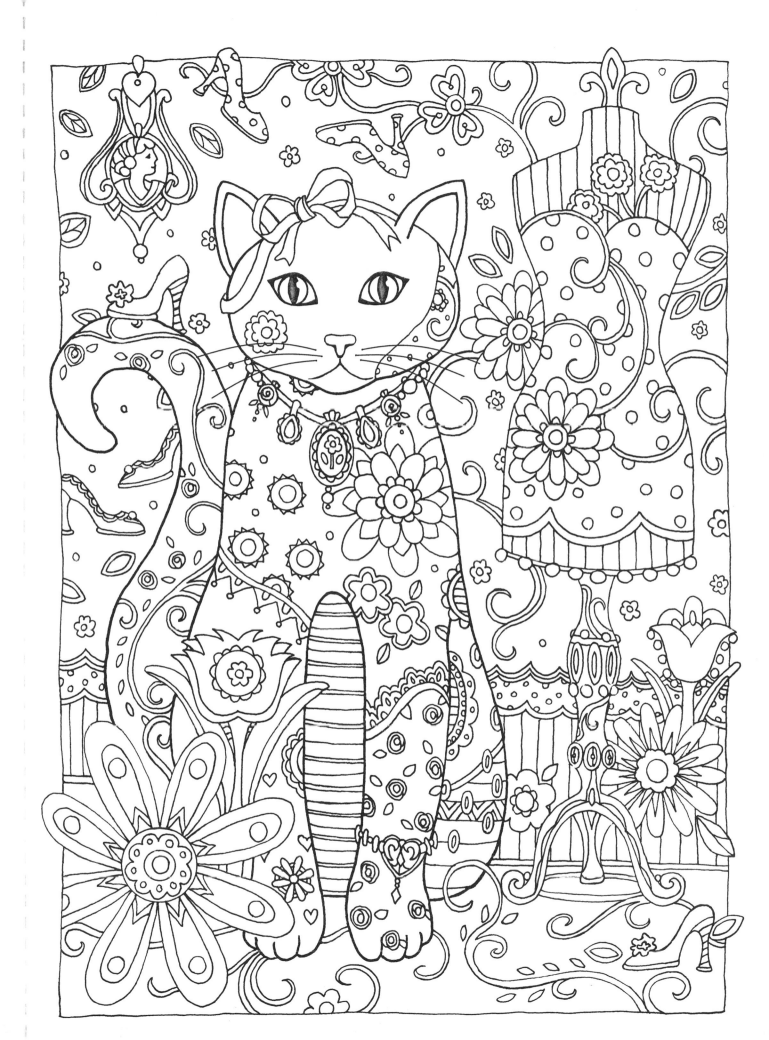

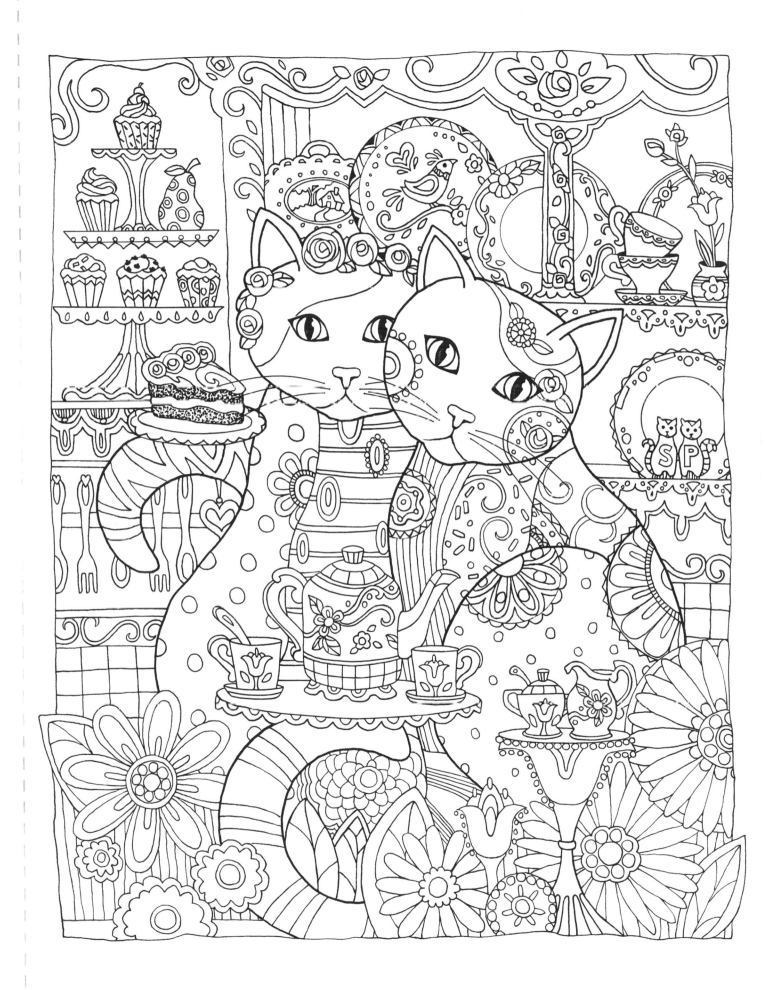

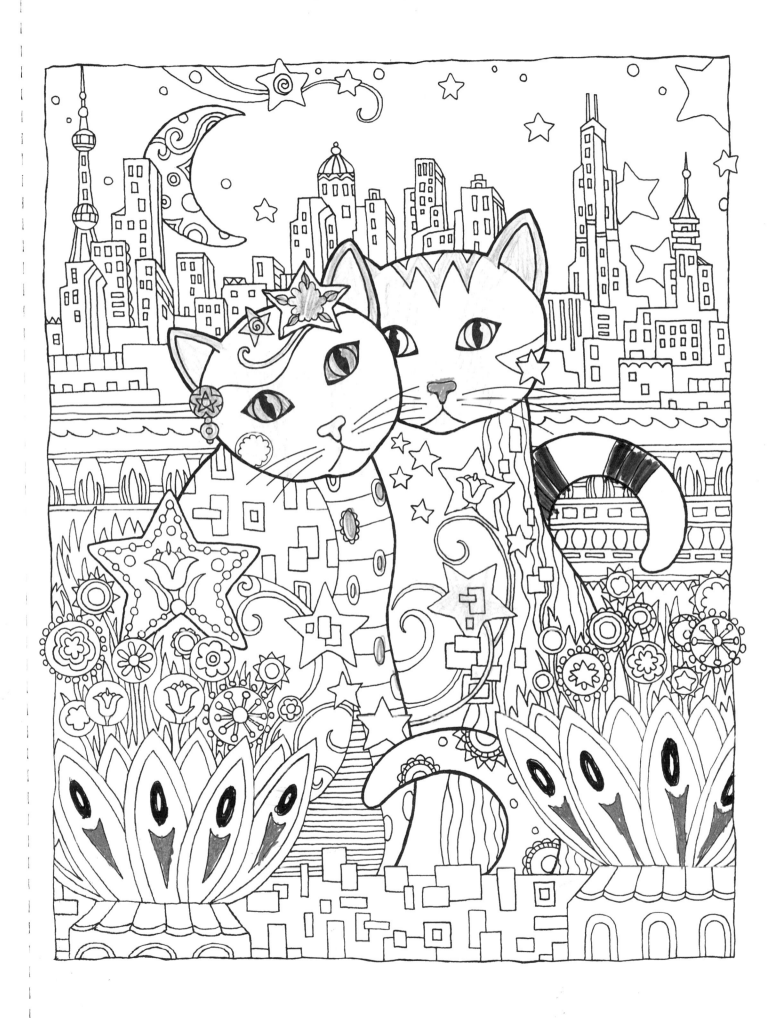

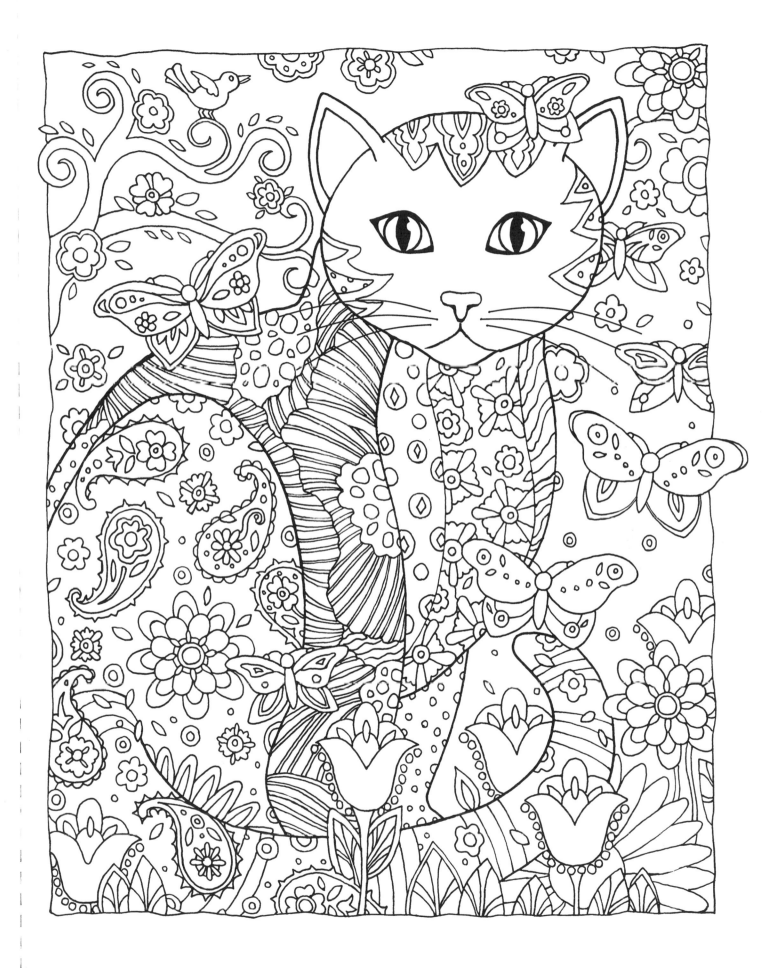

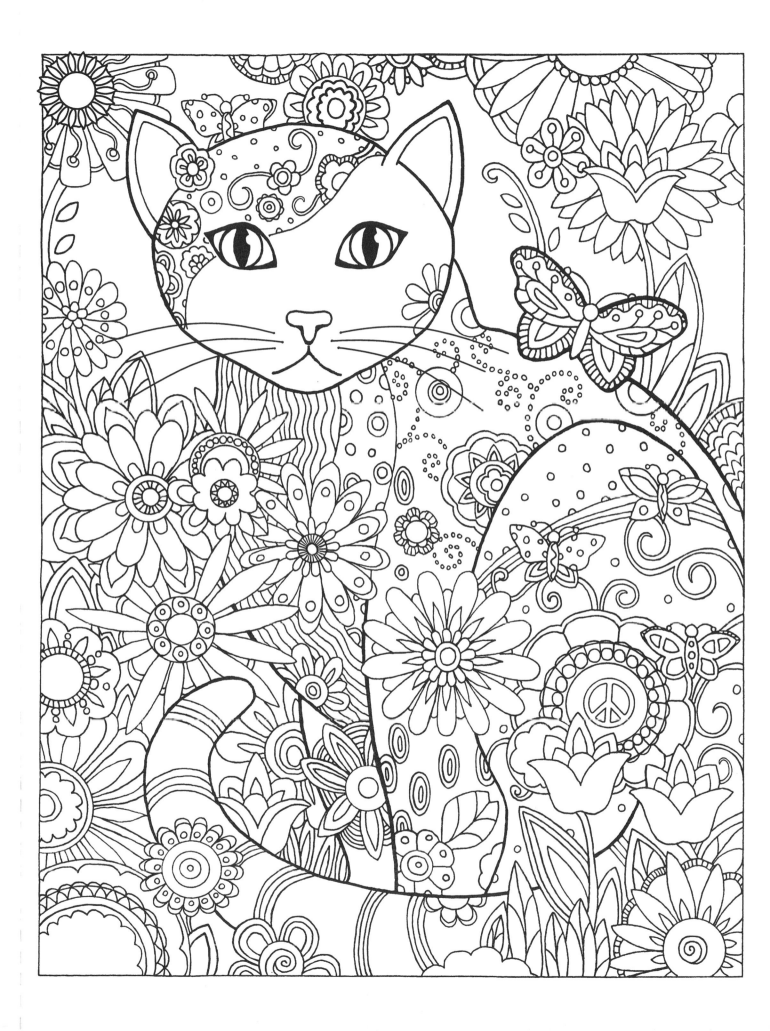

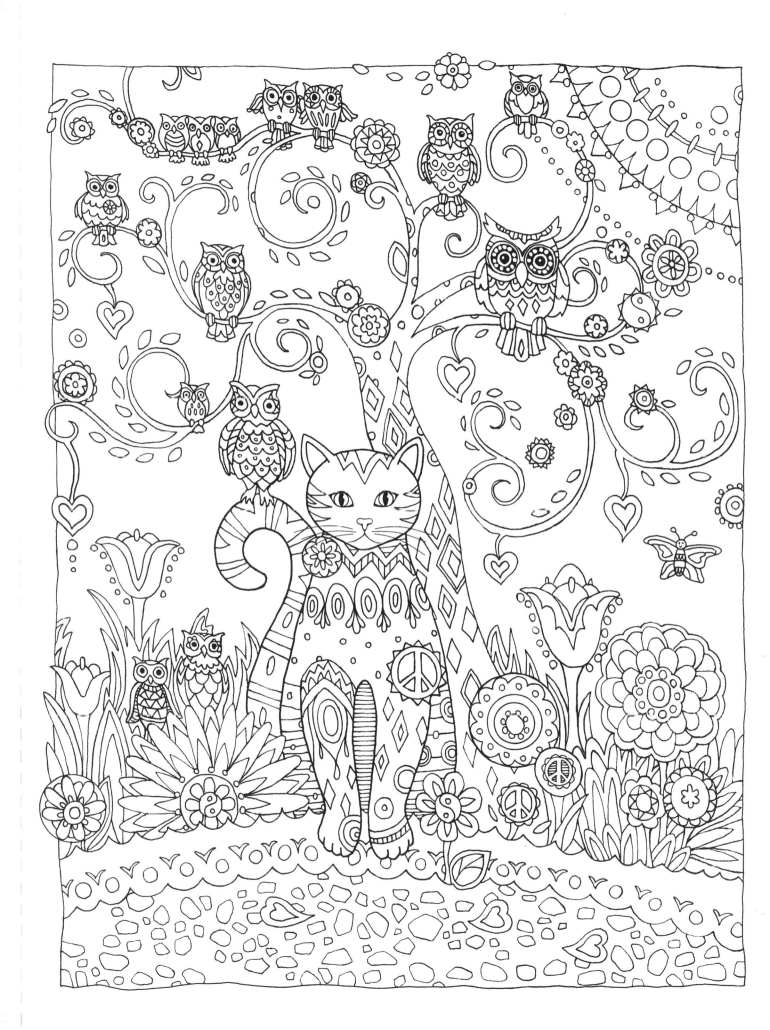

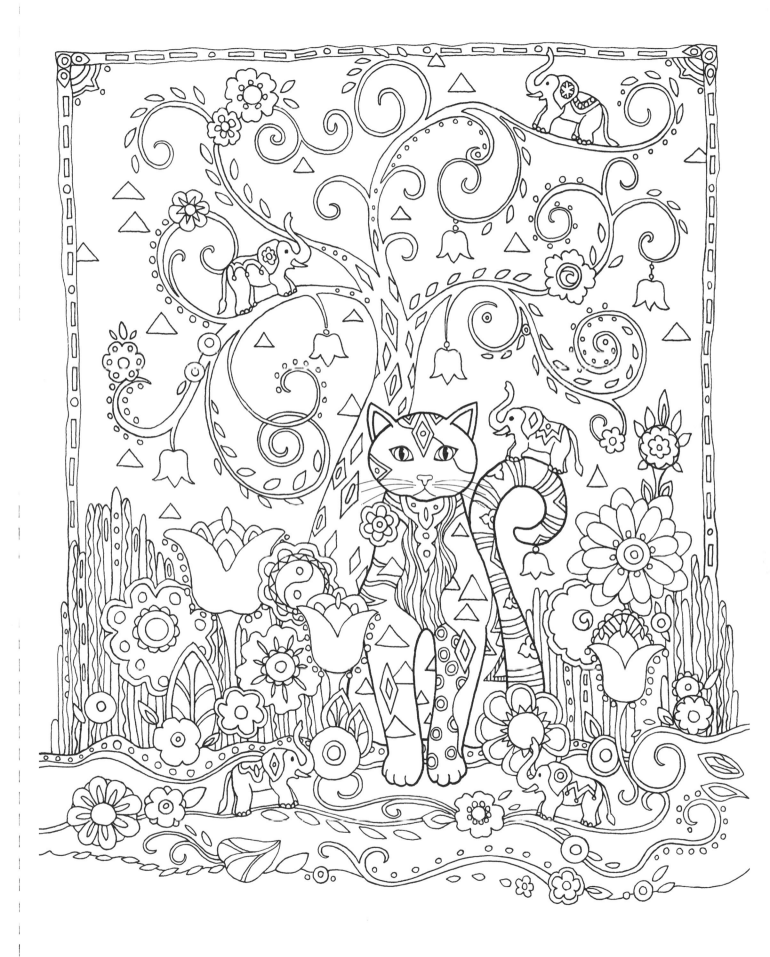

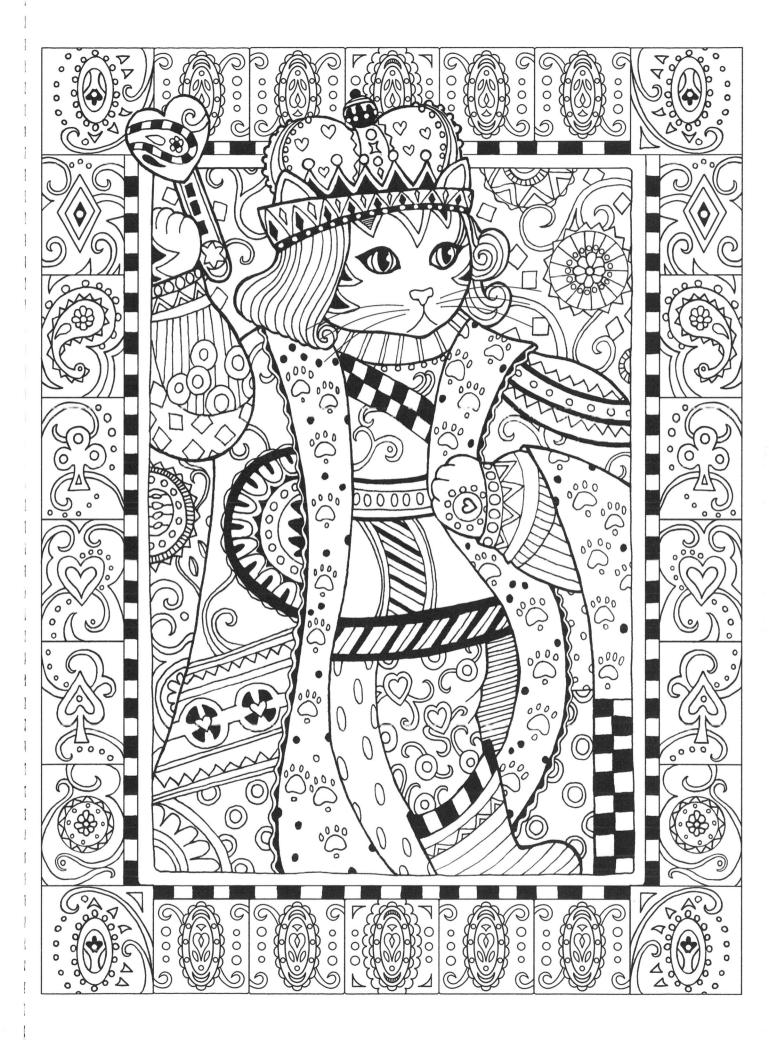

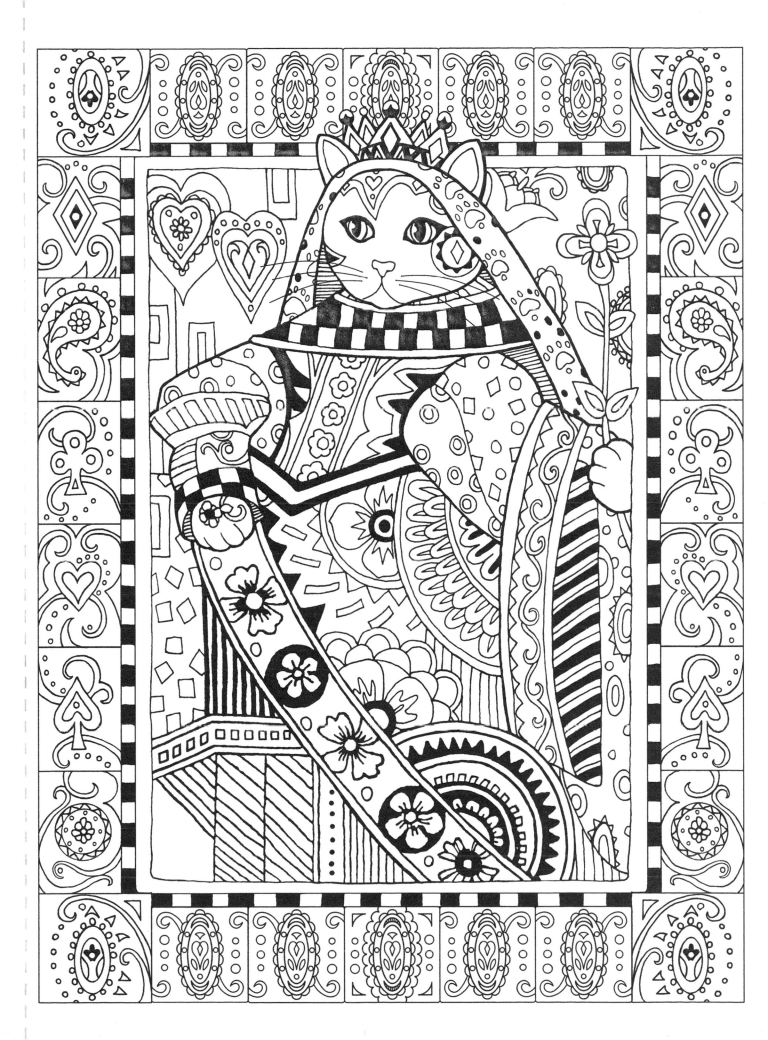

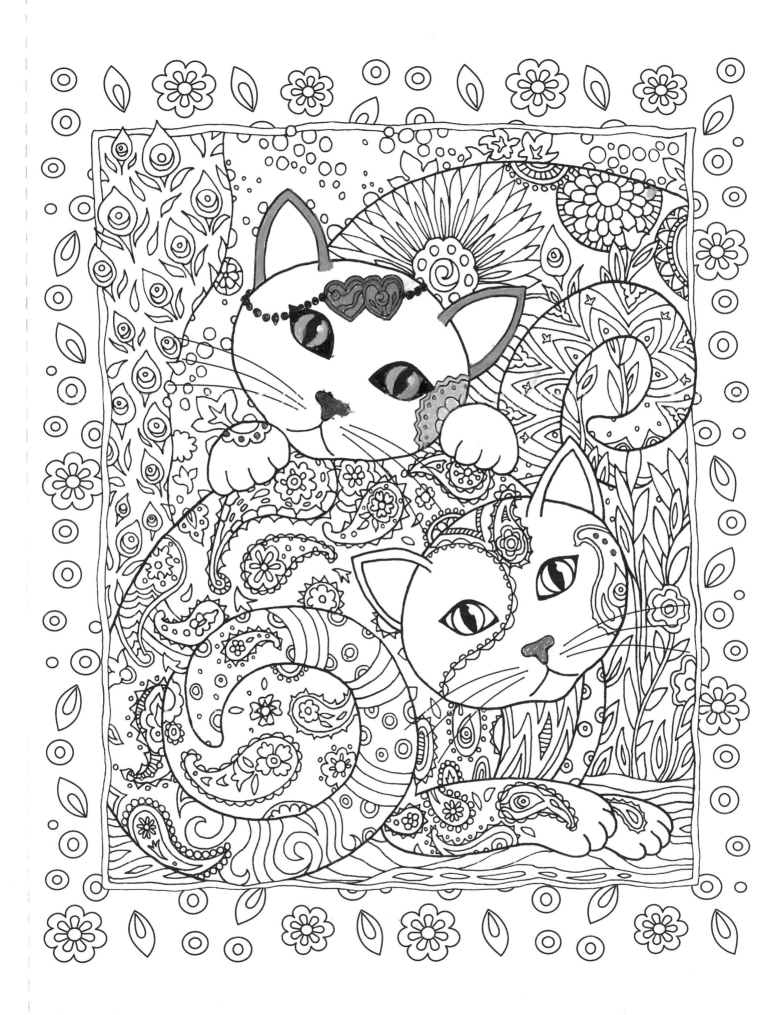

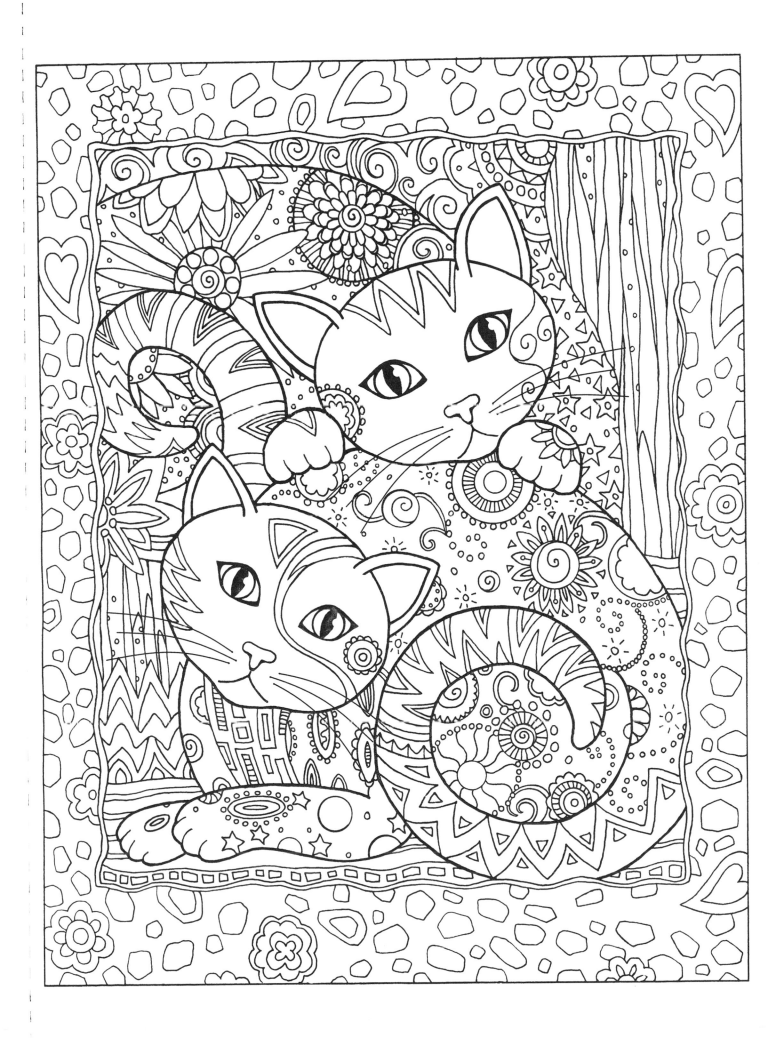

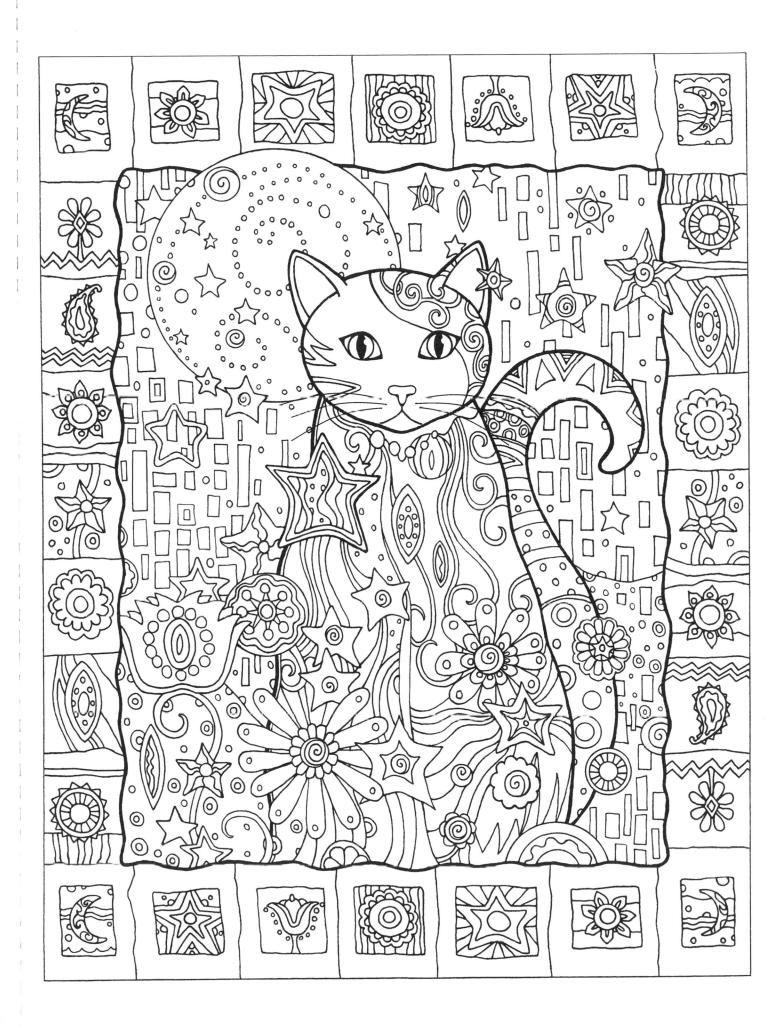

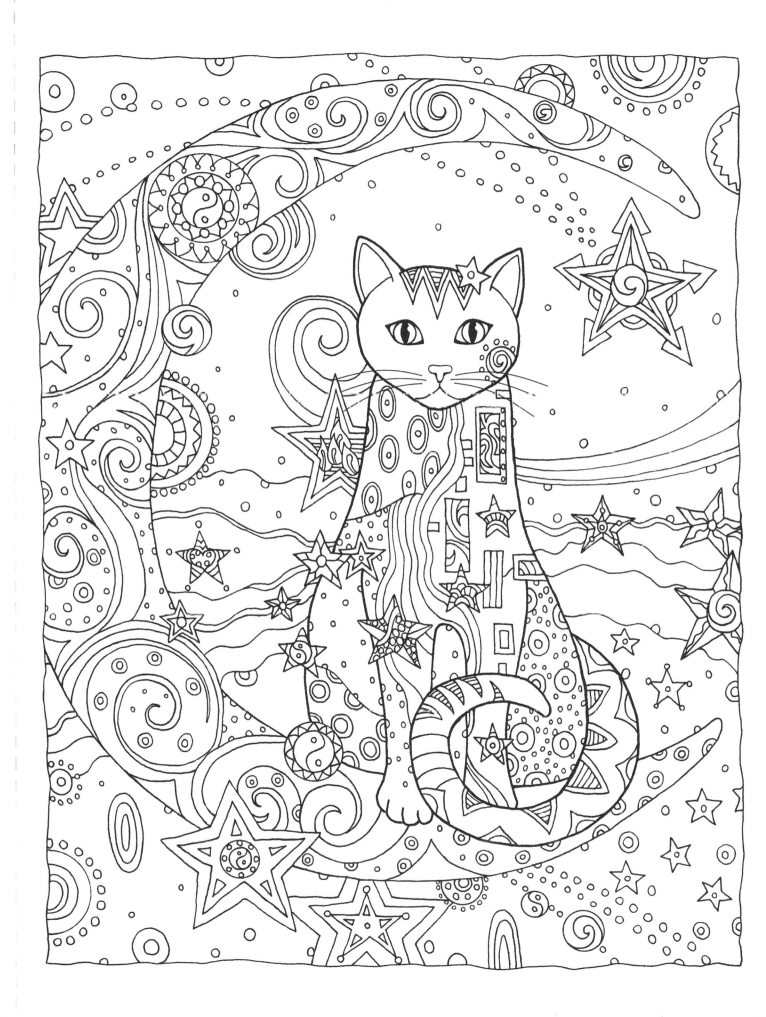

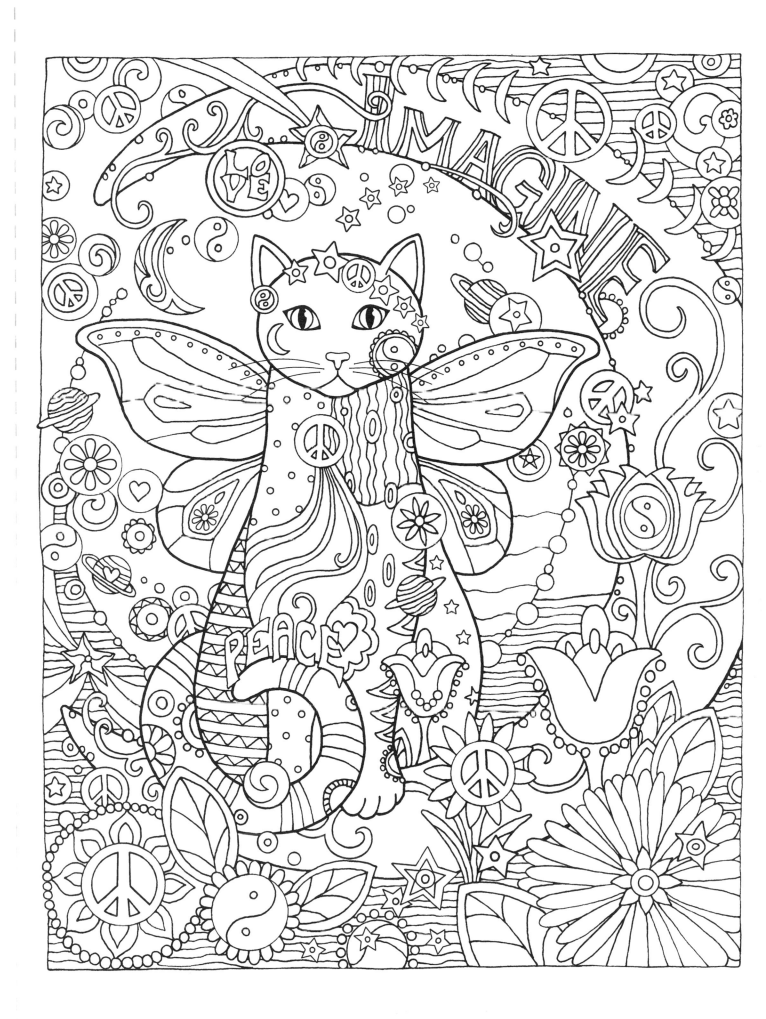

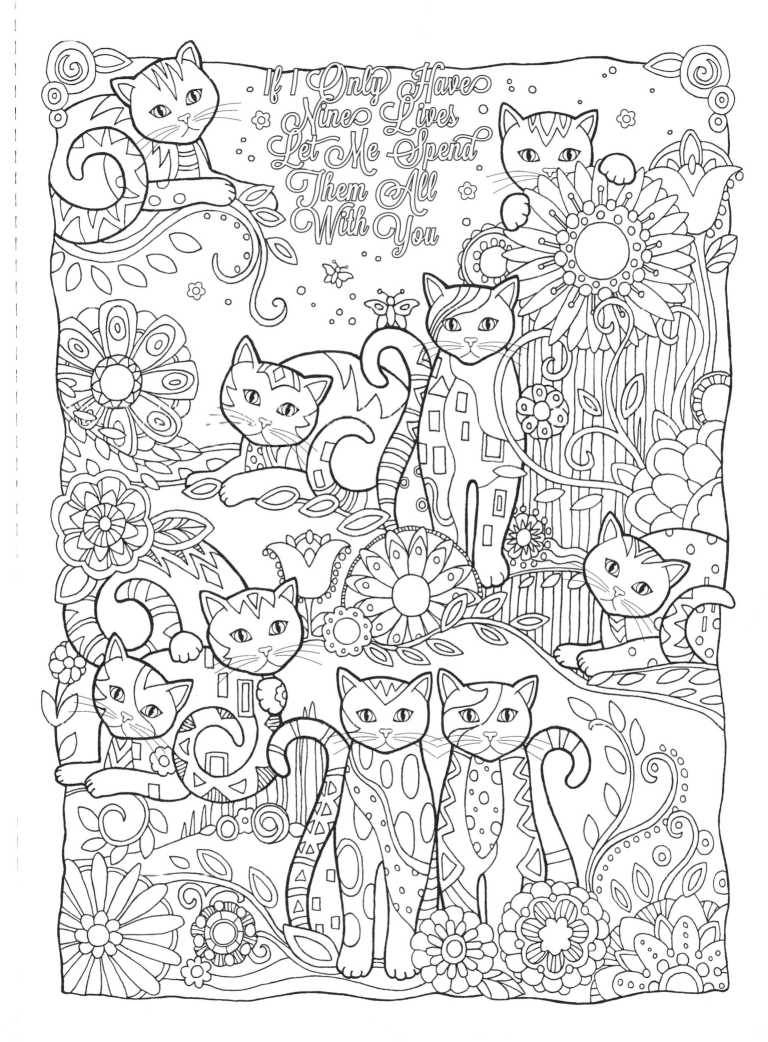

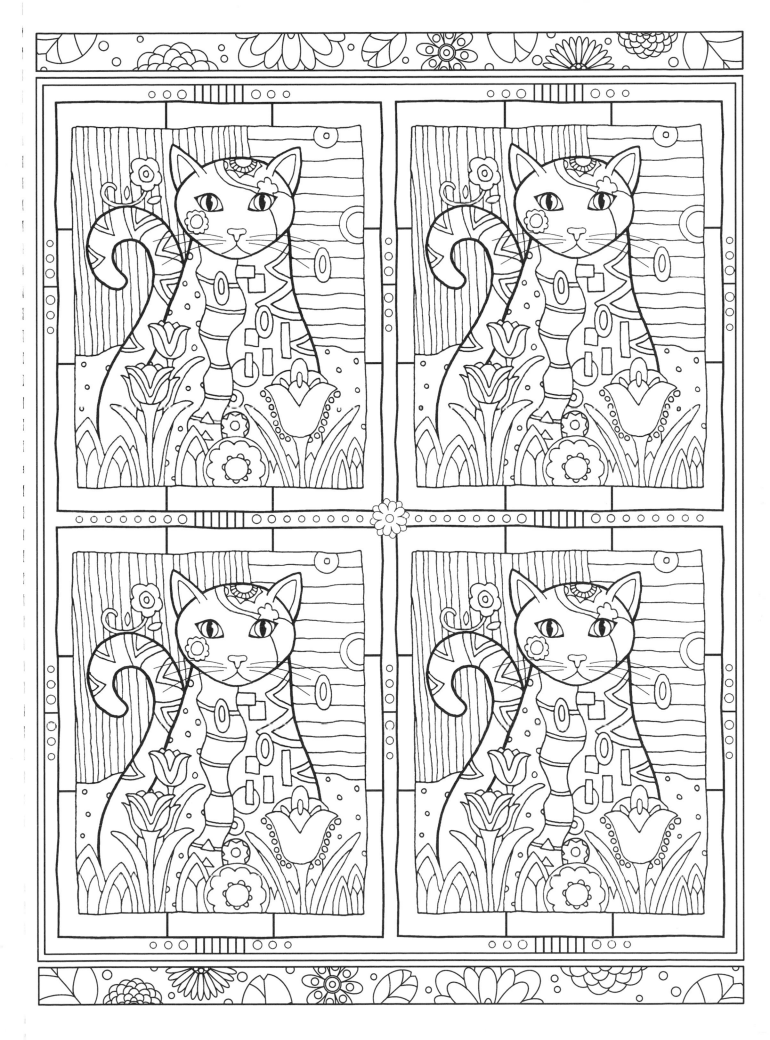

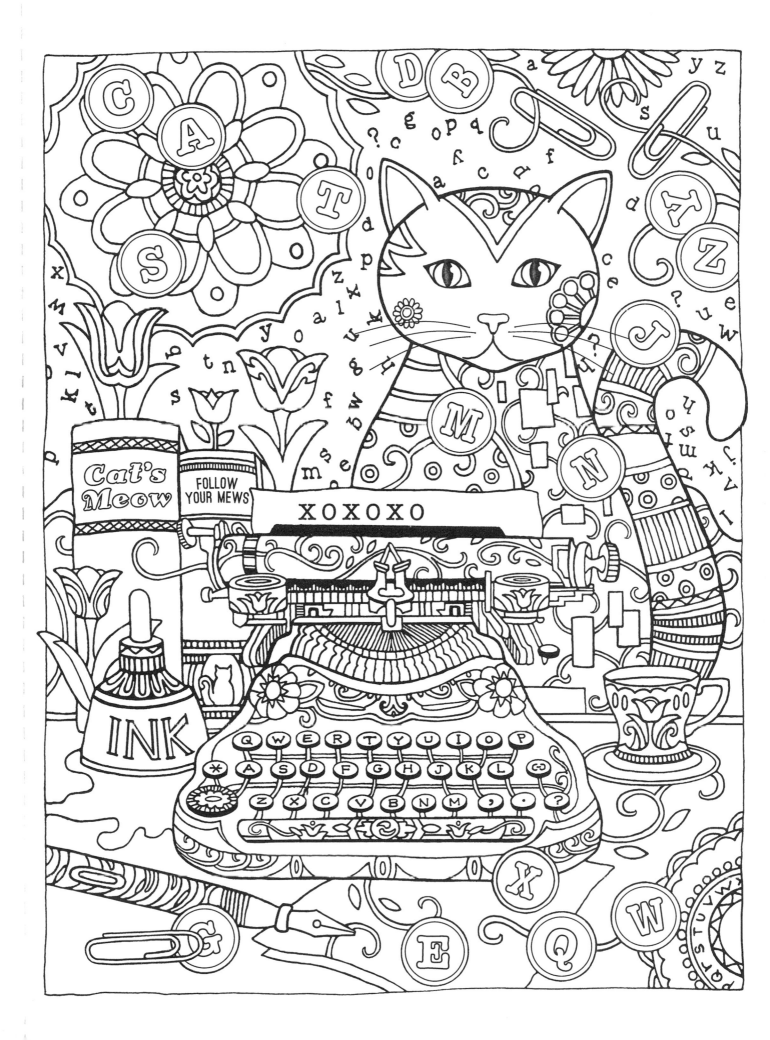

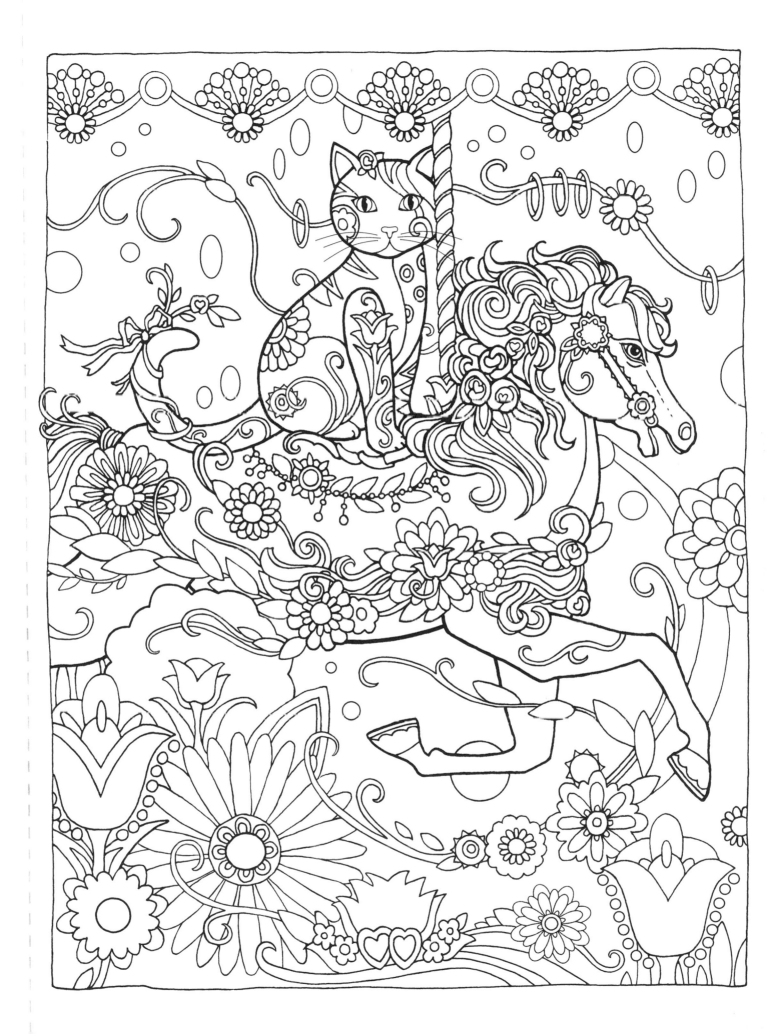

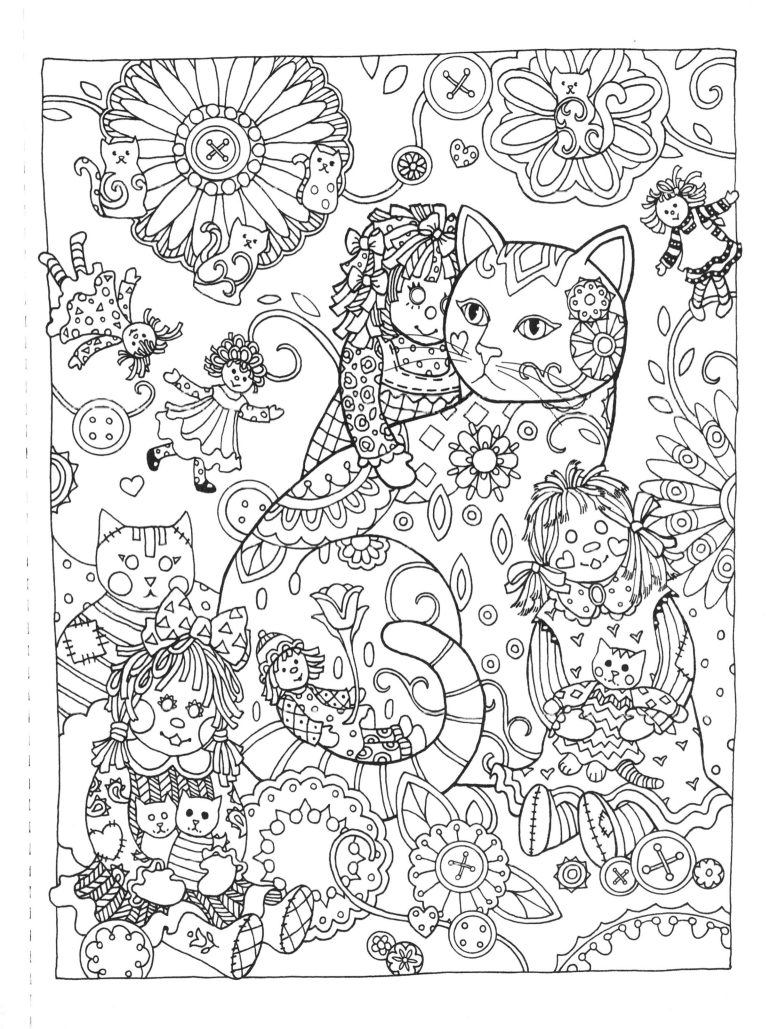

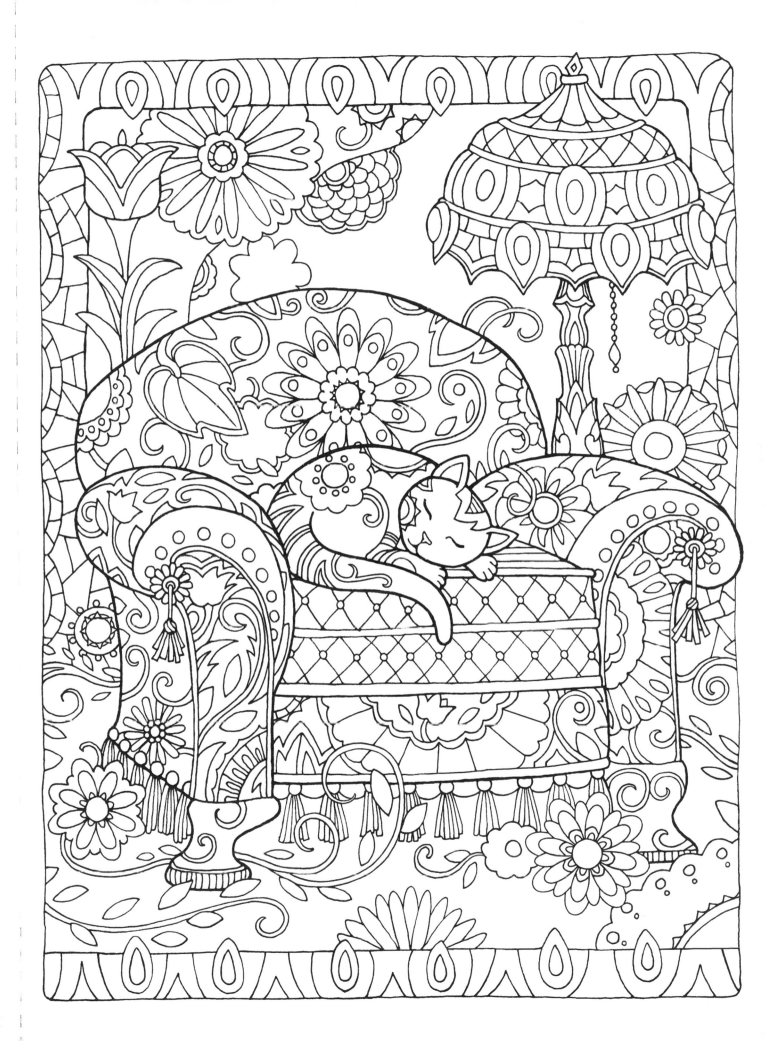

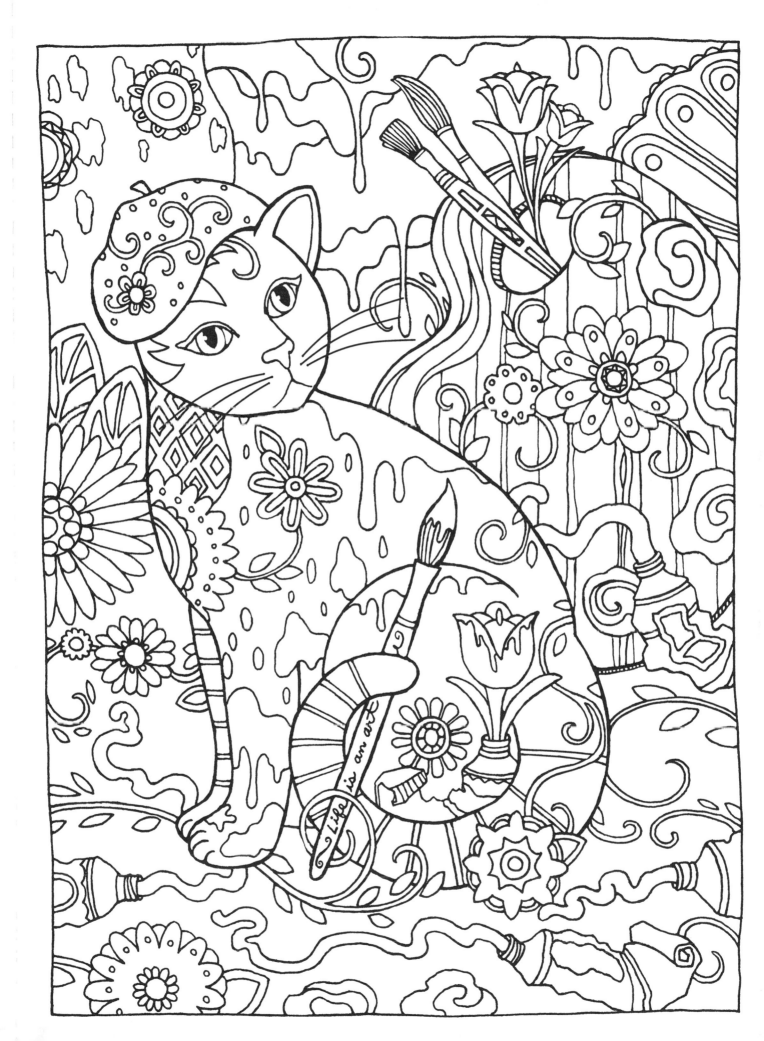

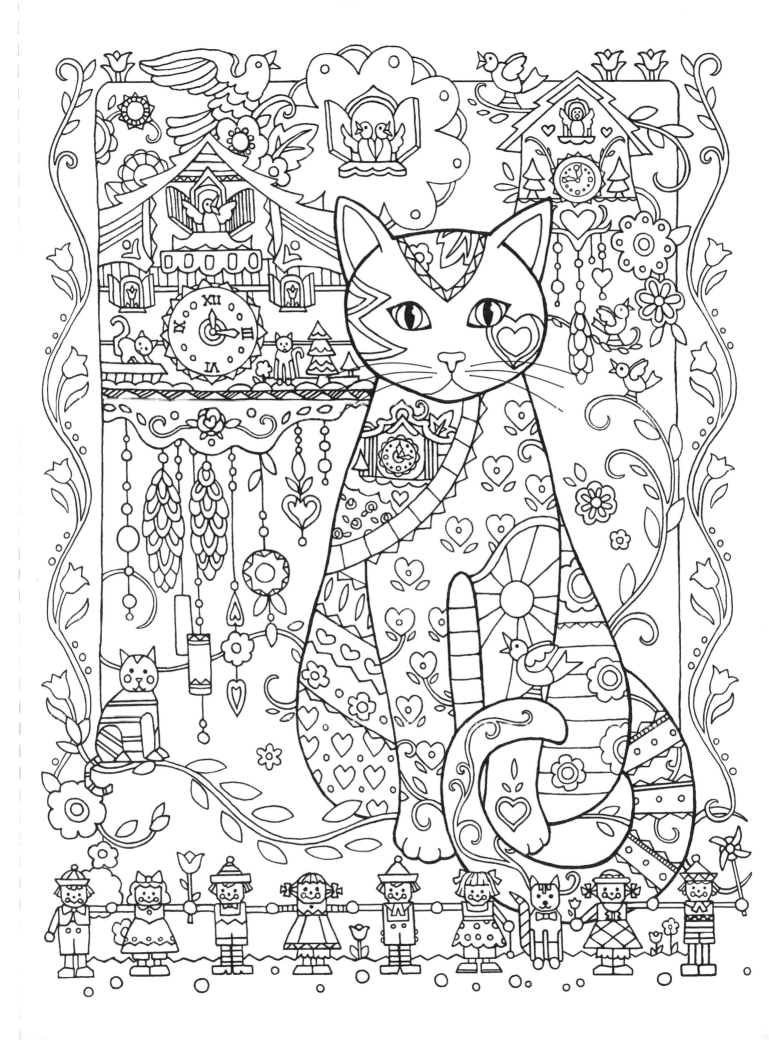

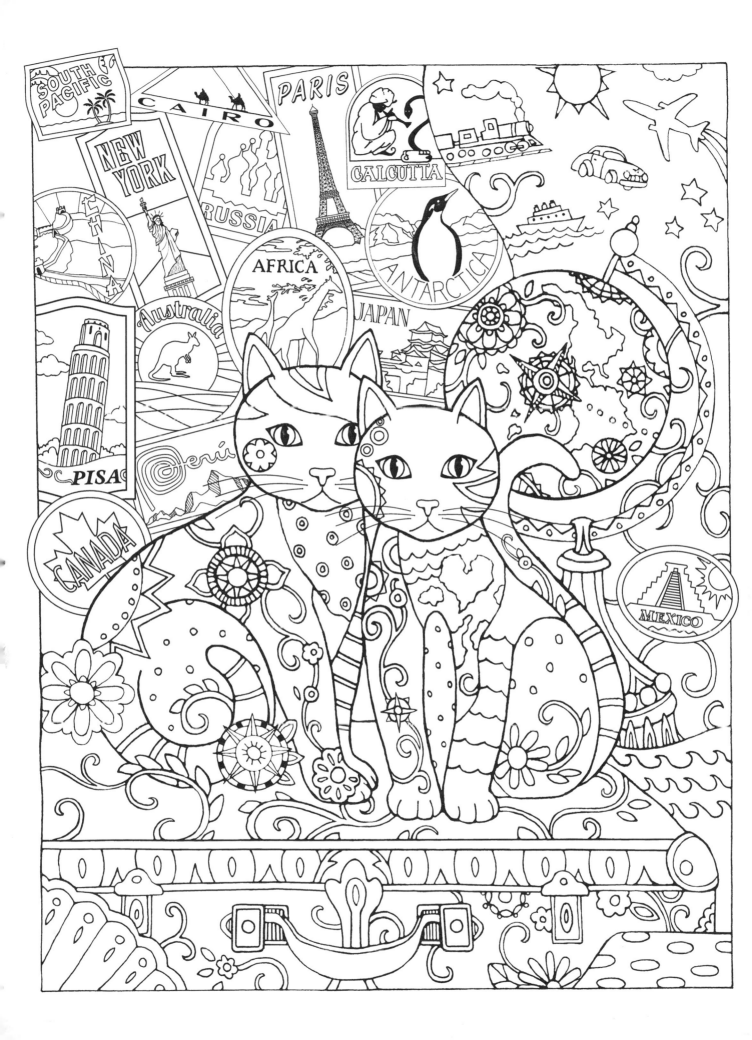